MY COLLECTION MAYBE YOURS!
WHY WE MUST HAVE IT ALL

From the guy who wrote
Baby, Boom, Boom—Baby, It's You!
brings you

MY COLLECTION MAYBE YOURS! WHY WE MUST HAVE IT ALL

TERRY WAYNE BROWNLEE

Copyright © 2019 by Terry Wayne Brownlee.

Library of Congress Control Number:		2019906048
ISBN:	Hardcover	978-1-7960-3351-9
	Softcover	978-1-7960-3352-6
	eBook	978-1-7960-3353-3

All rights reserved. No part of this book may be reproduced or transmitted in any form or by any means, electronic or mechanical, including photocopying, recording, or by any information storage and retrieval system, without permission in writing from the copyright owner.

The following does not represent the talents of the author.
Its goal is to entertain, excite, and inspire people about my hobby of collecting things.

Print information available on the last page.

Rev. date: 05/14/2019

To order additional copies of this book, contact:
Xlibris
1-888-795-4274
www.Xlibris.com
Orders@Xlibris.com
668567

CONTENTS

Introduction ... 1
My Reference Library ... 3
James Bond ... 5
Popular Culture .. 7
Best of Comic Books .. 17
Bond, James Bond .. 19
Magazines and Toys ... 23
Toy Box ... 26
Cookbook Library .. 29
Collecting Today .. 34
What New Things I'm Collecting this Year 35
What Do You Collect? ... 37
Final Chapter .. 42
Concept of Collecting .. 44
What Do You Collect? ... 47

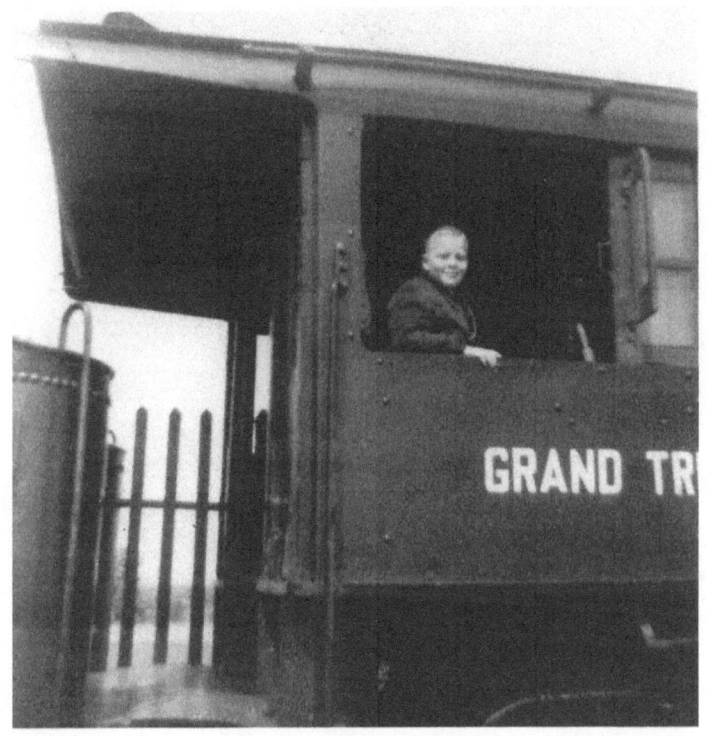

Terry Wayne Brownlee

Dedicated to all who collect

Dedicated to all fellow dreamers.
Here I was at a time when I just knew all was possible!

HOW TO READ THIS BOOK

The subject of what I collect encompasses many decades to the present. The following are what I collect: books, movies / TV shows, music, toys, and magazines. Some photos are used in promoting movies and products. As to what other people collect, I described and explained them. I have given advice on not getting caught up in the media hype and not letting what you collect get out of control. Telling people how and what I collect plays a part of my life and gives me hope for the future. What is happening today in collecting is, things you've seen for free back in the day now comes at a cost. Today, big-name stores and movie theaters now are almost gone. All has changed—even more reason why we should collect!

INTRODUCTION

The headline of an article read "Why We Like to Watch." Technology made it possible. The demand of modern life made it necessary. It's the largest audience in history, and its need to be entertained has defined the era. Here it begins—my search on how we baby boomers and generations beyond got caught up in consumer spending. As each decade unfolded, each generation got sucked in into being duped, conned, and persuaded into our next purchase. So say I, your friendly neighborhood self-appointed baby boomer consumer advocate.

The backstory of all this much surely must be from what we collect. As you see what I collect, and maybe yours, you will notice that the popular culture of the day is the biggest factor or driving force in what we collect and spend. You are either a big fan or must have everything collected, and soon it becomes an obsession!

What we may know (or care) is that this is a trillion-dollar marketing strategy that grabs your attention. For me, I just ask why we still want so much. To all who collect—whatever you collect—only you know what excites you. Many who don't collect do not get it. You are holding a piece of your life, most of which is long gone; but you can touch, feel, and hear what treasured moment it holds. Memories are such a fleeting thing. Hang on to what you've got, for the treasure you've got is priceless. My advice is to collect for the right reason, not because it says it is limited edition. The fun of collecting comes from the hunt—the chase!

Toys, Records, Movies, and Collector shows

What a great way to meet people you would not ordinarily meet. We have so much in common as sellers and customers.

The thread to all this lies within the popular culture of the day and of the past. We have all so many memories of the past, never mind the ups and downs of life's journey. We have daily and yearly exposure to music, movies, television, and print.

That of course depends on where your story begins. What demographic do you belong to? If you grew up in the 1970s, you were part of the Star Trek / Star Wars generation.

Before all that, you were part of the Pepsi generation—all part and parcel of the beginnings of the marketing strategies in your life that control how you spend your money.

Let's speed up to the here and now. Because of the advance in technology, everything has changed. We are now focused on the comic book heroes of the past and the reinvention of the story of how they became who they are, such as the case of James Bond, Batman, Star Trek, and Star Wars.

As a collector, you must have the complete set of each movie, TV show, and anything connected.

MY REFERENCE LIBRARY

If you are a fan of anything—say, a famous person—or just want to know something, this is the very best place to turn to as a reference. I never planned to get this library to be so large. For a long time, I had a keen sense of knowing what I liked and what fit into being creative.

ICONS
Marilyn Monroe

The Many Lives of Marilyn Monroe by Sarah Churchwell
Marilyn was called a goddess and an innocent child. She had been very manipulated, and she was both a dumb, liberated woman and a tragic loner. Marilyn Monroe was more complicated and credible than the one we thought we knew.

Conversations with Marilyn by W. J. Weatherby
A series of conversations any journalist would have revealed.

The Assassination of Marilyn Monroe by Donald H. Wolfe
Part 1: 1962–1998. Decades of deception. May I say more?

Pocketbooks Edition
Marilyn: Norma Jeane by Gloria Steinem
Gloria explores the real woman that hid behind the bombshell persona.

Goddess: The Secret Lives of Marilyn Monroe by Anthony Summers
This book is about her roller-coaster life; deception-shrouded death; divided, secret self; legion of lovers; intimacies with JFK and Bobby Kennedy; and mafia connection.

Marilyn: a Biography by Norman Mailer
This book is about sexuality, America, the perils of acting, the art and the terrifying Hollywood lifestyle written by Norman Mailer himself.

Marilyn Memorabilia: Putting a Price on the Priceless Performer by Clark Kidder

Marilyn Monroe 50th Anniversary Edition Book and DVD 2012 Box Set
This is a lavishly illustrated book plus a sixty-minute DVD chronicling her iconic life.

JAMES BOND

James Bond in the Cinema by John Brosnan
This was the very first book I purchased on James Bond, to whom I was introduced in grade 9 in the early 1960s. Who wouldn't want to escape into Bond's world?

LIFE: 50 Years of James Bond
Happy anniversary, Commander Bond. Sean has aged. Roger has aged. Pierce has aged. Daniel has aged a bit. James Bond has not.

The Films of Sean Connery by Lee Pfeiffer and Philip Lisa
The actor's life is almost as incredible as that of his cinematic alter ego.

A reference guide to the birthplace of 007 and his creator.

For Your Eyes Only by David Giammarco
Behind the scenes of the James Bond films

Golden Girl by Shirley Eaton
This book is rounded off by an image of glamor that has changed from the studio years of the 1930s and 1940s to the present day.

The Moneypenny Diaries. Edited by Kate Westbrook.
Also, the third book in the series is *The Moneypenny Diaries: Final Fling*

James Bond's London by Gary Giblin. Foreword by Peter Hunt.

Bond on Bond: The Ultimate Book on Over 50 Years of 007 by Roger Moore
A must-have for every Bond fan.

Other Icons

Madonna by Andrew Morton
At the age of forty-three, with a career that spans two decades and ranges from the scandalous to the transcendent, Madonna is a bigger icon than ever, always reinventing herself in each decade.

The Princess & The Package by Michael Levine
Was she a victim of the media or a willing accomplice? Diana knew how to work the system to get all that she was after.

Death of a Princess by Thomas Sancton & Scott MacLeod
Two of the best reporters from *Time* magazine based in Paris have undertaken the ultimate investigation of the death of Diana.

POPULAR CULTURE

MUSIC

Classic Tracks Back to Back: Singles and Albums with contractors from Johnny Black, Mark Brend, Michael Heatley, John Morrish, Rikky Rooksby, Thomas Jerome Seabrook, David Simons
The stories behind fifty years of great recording

America Complete
Songbook for guitar with chords and music. I bet this is hard to find.

The Ventures - Pipeline: 25 Surfin' Hits for Solo Guitar. Transcriptions by Don Liibertion.
You, too, can play the Ventures' greatest hits.

The Rock Pack (a pop-up book) by Ron van der Meer and James Henke
Featuring the Rock and Roll Hall of Fame and museum

Before the Gold Rush by Nicholas Jennings
Flashbacks to the dawn of the Canadian sound

COLLECTORS' GUIDE MUSIC

Goldmine's Price Guide to Collectible Record Albums. 3rd ed., 1949–1989 by Neal Umphred.
Covers the entire gamut from ABBA to ZZ Top

Golden Oldies: A Guide to 60's Record Collecting by Steve Propes
Track down memory lane and rediscover your favorite.

Solo in the 70s: John, Paul, George, Ringo 1970–1980 by Robert Rodriguez
The decade after the Beatles broke up

Real Life: Real Spice: The Official Story by the Spice Girls
Girl power was their manifesto. This book tells the world all about the international phenomenon of the Spice Girls.

LIFE with the Beatles: Inside Beatlemania, by Their Official Photographer Robert Whitaker

LIFE The Rolling Stones: 50 Years of Rock 'n' Roll

The Beatles vs. The Rolling Stones by Jim Derogatis and Greg Kot

COMIC BOOK COLLECTIBLES

Comics, Collectibles, and Their Values by Stuart W. Wells and Alex G. Malloy
Action figures, books, games, magazines, posters, and toys

TOYS

Nineteen Ninety-Four Toys and Prices. Edited by Roger Case and Tom Hammel.
More than twelve thousand toys listed. Over thirty-three thousand prices. 1866–1991 from the publishers of Toy Shop.

Yesterday's Toys: Robots, Spaceships, and Monsters by Teruhisa Kitahara. Photography by Masashi Kudō.
This book contains full-color photographs of toys.

BOYS' TOYS

Boys' Toys of the Fifties and Sixties: Memorable Catalog Pages from the Legendary Sears Christmas Wishbooks 1950-1969. Edited by Thomas Holland.
Sears' wish list 1950–1969

TV Toys and the Shows that Inspired Them by Cynthia Boris Liljeblad
This reference book is your best guide to TV collectibles.

Hake's Guide to TV Collectibles: An Illustrated Price Guide by Ted Hake

The Collector's Guide to Toy Cars: An International Survey of Tinplate and Diecast Cars from 1990 by Gordon Gardiner and Richard O'Neill

Toys: Celebrating 100 Years of the Power of Play by Chris Byrne
The best of the best in toys' hundred-year history.

AutomYear Book of Models 2: 1983 by Ian Norris
The lavishly illustrated first installment of a new series of annuals designed for model makers and collectors and a guide to antique toy investors.

Window to the Future: The Golden Age of Television Marketing and Advertising by Steve Kosareff
Showing a collection of 150 vintage ads and inmates from magazines and brochures that sold TV to the public.

The Monkees Tale by Eric Lefcowitz
Telling how the Monkees came to be, their two seasons on TV, and what happened before and after they became pop icons.

Monkeemania: The True Story of the Monkees by Glenn A. Baker with Tom Czarnota and Peter Hogan
"Hey, hey, we're the Monkees." How they came to be.

The Toys from U.N.C.L.E.: Memorabilia and Collectors' Guide by Brian Paquette and Paul Howley
Who was a fan of *The Man from U.N.C.L.E.* TV series? Just look at all the cool stuff you all could get.

The Incredible World of Spy-Fi by Danny Biederman
Features the gadgets, props, and artifacts from *James Bond, The Man from U.N.C.L.E., The Wild Wild West, Mission: Impossible*, and much more!

The Twilight Zone Companion by Marc Scott Zicree
The complete show-by-show guide to one of the greatest

Doctor Who: The Handbook: The First Doctor: The William Hartnell Years 1963–1966 by David J. Howe, Mark Stammers, and Stephen James

A Biography of Vince Edwards by George Carpozi
The inverent, unbiased, unauthorized book about TV's most famous Doctor and his colleagues.

AUDIOVISUAL COLLECTION

Best of VHS

Alfred Hitchcock—*Vertigo/Psycho/Saboteur*

Woody Allen—*Love and Death / Galactica 1980 / Shirley Temple—Curly Top / Apocalypse Now*

Buck Rogers in the 25th Century / Star Trek II: The Wrath of Khan / The Best of "I Love Lucy" Collection 2 VHS

V: The Original Miniseries 2 VHS (Hi-Fi) / Blake Edwards—*A Shot in the Dark* / *The Thomas Crown Affair*—New Version VHS/ Old

Abbott and Costello starring in *Buck Privates* and *Ride 'Em Cowboy* VHS / Superman 1940s cartoon / *Lady and the Tramp*

Mighty Morphin Power Rangers—"High Five"

Very Best LP

Donna Summer—*Greatest Hits* / *Vol. 2* / The Rolling Stones' *12 X 5* / Eric Burdon's *Greatest Hits*

Electric Sixties—All Original Master Records / *Burt Bacharach Plays His Hits*

Hooked On Classics / Rare Earth—*Get Ready* / *The Golden Age of Hollywood Comedy*—Laurel and Hardy

North by Northwest Digital Film Score Series Vol. 1 / *Rock 'n' Roll Fever 1 and 2* / André Gagnon—*Greatest Hits*

Barbra Streisand—*One Voice* / *The Searchers' Smash Hits* / *The Deep Music Soundtrack* / W Poster

Jon and Vangelis—*The Friends of Mr. Cairo* / Opus—*Up and Down* / *West Side Story* / The Monkees—*Pool It!*

The Best of Jethro Tull Vol. 1 and 2 / *Monterey International Pop Festival*—The Mamas and the Papas

Electric Light Orchestra—*Out of the Blue* / The Beatles—*Something New* / *Diva* movie score / The Beatles' *Live! at the Star-Club in Hamburg, Germany; 1962*

Fred Rogers—"Won't You Be My Neighbor?" / Supertramp—*Breakfast in America* / *Golden Summer Hits*

The Alan Parsons Project—*Eve* / *Pure Delight with Danny Kaye* / Sharon, Lois & Bram—*One Elephant, Deux Éléphants*

The Manhattan Transfer / *Best of The Zombies* / Supertramp—*Crime of the Century*

Best TV Series Ever

Harry and Wally's Favorite TV Shows: A Fact-Filled Opinionated Guide to the Best and Worst on TV by Harry Castleman and Walter J. Podrazik

Doctor Who: The Official Annual 2012 by BBC TV
The legend continues. They saved the whole universe from certain destruction. Now Amy and Rory are married, and their adventures continue.

Pocketbook Editions

The Television Years: A Rich Feast of Nostalgia, in Pictures and Text by Arthur Shulman and Roger Youman

The Monkees—*Selections from the Headquarters Sessions* / Dick Clark—*20 Years of Rock n' Roll*

An Invitation to Rock n' Roll Anniversary Paul Revere & the Raiders—*Greatest Hits with Color Photo Book*
Nuggets Volume 11: Pop, Part Four / *Golden Graffiti Greats*

DVD Box Sets

The Monkees—Season 1 and 2—Many Extra Features

The Ultimate Roy Rogers Collection—Five-DVD Set / Twenty-Five Full-Length Feature Films

The East Side Kids—Two-Pack DVD Set Collector's Edition

Toho Pack—The Mysterians / Varan the Unbelievable / Matango: Attack of the Mushroom People—Three-DVD Set

The Adventures of Rocky and Bullwinkle and Friends—Complete Season 1

The Arches series—The Complete Series

Route 66—Series 1 and 2—Complete

Great Events of Our Century: Events Which Shaped Our Lives Five-DVD Set

The 3 Complete Ed Sullivan Shows Starring Elvis DVD Set

20 Wild Westerns: Marshals & Gunmen Four DVDs

Alfred Hitchcock's Psycho / Special Edition 2 DVDs Digitally Remastered

Bond 50: Celebrating Five Decades of Bond 007—Complete—Blu-Ray

A Big Box of Cowboys, Aliens, Robots, and Death Rays—Four-DVD Set / *The Best of Tennessee Tuxedo and His Tales / Schemes*

Schwarzenegger—Double Feature: Total Recall / Terminator 2: Judgement Day 2 DVD Set

Sci-Fi Collection—61 Features / Ten-DVD Set / *Lost: The Complete First Series*

TV Series & Movie Collection

Best of Laredo: Season 1 three-DVD set / Original Classics—Marilyn Monroe ten dics

The Cliff Richard Collection—*The Young Ones* / *Summer Holiday* / *Wonderful Life* three-DVD set

Tin Box DVD

The Three Stooges Collection 6-Movie Set including *Have Rocket, Will Travel, The Three Stooges Meet Hercules, The Outlaws Is Coming*

The Three Stooges: Collector's Edition: "Nyuk, Nyuk, Nyuk" four-DVD set, Three Stooges commercials, cartoons, and movie trailers

America History of the Wild West—12-Documentary Set—Billy the Kid, Wild Bill Hickok, Wyatt, Cole Younger, Jesse James

Dream Machines: America's Passion for the Open Road (filmed in high definition) five-DVD set

CD Tin Box

Hits of the 70s—Collector's Edition - three dics (very amazing, as I hear it again) / *60s British Invasion—Collection Edition* (many live versions of Britsh hits)—3 CDs / *Guitar Rock Collector's Edition*—3 CDs (the best played here) / *Summer of Love Collector's Edition 3*

CD Box Sets

Remember Then: Vocal Groups From the Doo Wop Era—three CDs / The Best of James Bond—30th Anniversary—two-CD ultra set

George Harrison—*Brainwashed*—CD/ DVD (his last recording) / The Monkees—three CDs / Also Monkees—*Headquarters*, two CDs

Ultimate Dance—98—CDs
More DVD Box Sets

The Man from U.N.C.L.E.—The Complete Series

Alfred Hitchcock, Three of His Best Films—*Notorious / Rebecca / Spellbound*

The Prisoner (Blu-Ray)—The Complete Series five-DVD set

Irwin Allen's *Lost In Space*—The Classic Sci-Fi Adventure Series—Season 2 Volume 1 four-DVD set

Sea Hunt Season 1 DVD Plus VHS—24 Hours Of Sea Hunt—eight-DVD set Volume 14, a sample of each season

Tin Box

Dream Machines—*America's Passion for the Open Road* (High Definition) five-DVD set

CD Tin Box

Hits of the 70s—Collector's Edition - three dics (very amazing, as I hear it again) / *60s British Invasion*—Collection Edition (many live versions of Britsh hits)—3 CDs / *Guitar Rock Collector's Edition*—3 CDs (the best played here) / *Summer of Love Collector's Edition 3*

Laser Videodisc

Alfred Hitchcock—*North by Northwest*—Deluxe Edition

James Dean—*Rebel Without a Cause*

Rambling Rose—Pioneer Special Edition

Walt Disney Presents: Shipwrecked

Rain Man—two-disc Best Picture 1988

BEST OF COMIC BOOKS
Seller Kadia

Note: Value depends on what version Overstreet it is based on. Most comics are sealed.

Dell *The Aquanuts* 1 Fine Overstreet value US $33.74

Marvel 1 of 5 *Spider-Man/Doctor Octopus: Negative Exposure* (Direct Edition) Very Fine Value US $2.80

Harris H Comics *3: Vengeance of Vampirella* Classic Very Fine Value US $2.80

Archie *Giant Series 29: Archie's Pals 'n' Gals* Fine US $22.40

DC 1993 3 3 505 Foil *The Adventures of Superman* Near Mint Value US $12.50

Dark Horse *Star Wars Episode 1: Queen Amidala* Near Mint Value US $4 3.75

Marvel *(225 Series) 21 Iron Man* Very Fine $3.75 U.S

Dell (internet purchase) *Sea Hunt* Oct/Dec
Charlton Comic 8 *Abbott & Costello* Very Fine (1968 Series) Value $17.82

Harris H Comics (Part 1 of 6—Part Vampi Universe with Poster) *Vengeance of Vampirella—The Mystery Walk*—Purchased through The Comic Post

Grant Morrison—Ian Gibson—Book 1 *Steed and Mrs. Peel*

The Rocketeer: The Official Movie Adaptation 1 Very Fine Value US $2.81

Marvel Comics Captain America—Street of Poison (Plus Return of Bullseye!) Very Fine Value US $2.33

Essential Vertigo: DC Comics Swamp Thing Near Mint US $3.00

Topps Comics 1 of 30 *Xena: Warrior Princess; And the Original Olympics with poster—* Terese Nielsen Near Mint US $3.75

Marvel Issue 74: Ultimate Spider-Man Hobgoblin: Part 3 Direct Edition Near Mint US $6.25

BOND, JAMES BOND

James Bond in the Cinema by John Brosnan. This is my first book on the behind the scenes. It is the benchmark for all the Bond movies that are to follow. Published in 1972.

Golden Girl by Shirley Eaton. The book is rounded off by a look at how images of glamour have changed from the studio years of the 1830s and 1940s to the present, telling how she became the darling of the English public.

For Your Eyes Only by David Giammarco. Behind the scenes of the *James Bond* films by David Giammarco. "Fascinating stories, details, anecdotes . . . David Giammarco's book is about the Legacy that of 007."

James Bond's London: A Reference Guide to the Birthplace of 007 and His Creation by Gary Giblin. Foreword by Peter Hunt with special tribute to Ian Fleming by Christopher Lee.

The Films of Sean Connery by Lee Pfeiffer and Philip Lisa. This gives an alphabetical listing of Sean Connery's top-grossing films.

For Your Eyes Only: Ian Fleming and James Bond by Ben Macintyre. The major exhibition at the Imperial War Museum. This book was sent to me by my longtime pen pal from England, Phil Metcafe.

The James Bond Girls from Dr. No to Tomorrow Never Dies by Graham Rye (softcover edition). The James Bond girls, like 007 himself, have become part of cinema legend.

John Lane's *The Themes of 007: James Bond's Greatest Hits Made for Piano*. I am sure very hard to find.

The Official James Bond Movie Book Special 25th Anniversary Edition by Sally Hibbin. Foreword by Albert R. Broccoli. "Guaranteed to send the millions of Bond fans to 007 heaven."

James Bond: A Celebration by Peter Haining. "James Bond is not just a screen hero, he is an institution and such has influenced world affairs, art, music, motion picture and fashion."

The Book of Bond, James Bond by Hoyt L. Barber and Harry I. Barber

Puzzles—159-piece jigsaw puzzle—*The Spy Who Loved Me* / *Thunderball* James Bond 007 Jigsaw Puzzle—Over six hundred interlocking pieces ("Bond's Battle") / James Bond 100 Postcards—Complete

James Bond Micro Machines—original-scale miniatures / James Bond Jr. (sports car)—multi-feature, supercool vehicle

James Bond radio-controlled car—*Die Another Day* (fully functional)—Jaguar XKR Roadster (Unopened or Used)

Bond Die-cast Car—007 CV - *For Your Eyes Only* (unopened) / *Die Another Day* (as driven by James Bond)—Aston Martin V12 Vanquish

Auto Art Presents—The James Bond Colllection—*Goldfinger* (when I bought this, it cost me $75.00)—amazing box and working parts

Sideshow Collectible twelve-inch figure
Thunderball with Poster—"Look Up, Look Down, Look Out!" / *Moonraker*—Jaws With Great

Poster—*Die Another Day*—Great photo of Halle Berry as Jinx / *Moonraker*—Roger Moore as James Bond—Outer Space belongs to 007 / Celebrate eleven out of fourteen in five decades of Bond 007—Bond 50 (Box set—Blu-Ray)

The very first of collecting Bond—in a small suitcase.

Magazines—*Bondage*—from England and also *Starlog* ("Filmmakers Share Cinema Secrets," "Bob Simmons: Trading Punches with James Bond") / *Starlog* ("Cubby Broccoli Will Go On Forever!") / Magazine—"Mr. Kiss Bang Bang"—"The Summer of '77"

People Magazine—"Pierce Brosnan Sounds Off on His Battle to Be the New James Bond" / Magazine—*Licence to Kill*

Magazine—*Cinematographer*—"The Filming of *For Your Eyes Only*" / Comic—*For Your Eyes Only* / *The Official* Octopussy *Movie Magazine* / James Bond Fan Club—England—Poster Offer Back Issues / Photo World—A Collection of Full Color

Still Lobby Cards / Color of Roger Moore in *Live and Let Die* / Lobby Card of *On Her Majesty's Secret Service*

"Fascinating stories detail to the 'Legacy' that is 007." (Roger Moore).

Golden Girl by Shirley Eaton. "A sheer delight, a firefly emotional experience . . ." (Mickey Spillane). /

The Films of Sean Connery by Lee Pfeiffer and Philip Lisa. "Indeed, the actor's own life is almost as incredible as his cinematic alter ego." / James Bond's London. A reference guide to the birthplace of 007 and his creator. James bond's London is a must for armchair travelers and real-life adventurers alike.

From Russia with Love—1 Shoot / Dr. No—1 Shoot / *Thunderball*—1 Shoot / *Diamonds Are Forever*—1 Shoot

Meet James Bond—*From Russia with Love* / James Bond Is Back in Action—*Goldfinger* photo—Little Nellie

Die Another Day—Card/ Poster Set / Oo-Heaven News of the World—Exclusive Behind the Scenes—Casino Royal—Best of Bond Girls

Game—*007 Edition Scene It? The DVD Game* Mini Mission / Framed Mini Poster—Austin Powers / Wooden From—Bond Gun Shoot

More Bond Books—*Corgi Toys* by David Cooke / *Bond and Beyond: The Political Career of a Popular Hero* by Tony Bennett and Janet Woollacott

James Bond in the Cinema by John Brosnan. Note: This is the very first Bond book in my collection. It is also the very best.

For Your Eyes Only: Behind the Scenes of the James Bond Films by David Giammarco. *007 James Bond: A Report* by O. F. Snelling / Great Pan Books Goldfinger (Unabridged) / Signet Books—*The Man with the Golden Gun*

The Rough Guide to James Bond: The Movies, the Novels, the Villains / Pan Books *James Bond: The Authorized Biography* by John Pearson

James Bond DVD Dossier—From *Dr. No* to *Casino Royale*. Every Bond film on disk reviewed and rated / *The Bluffer's Guide to Bond* by Mark Mason

TV Guide Special Collector's Edition: *Totally Bond* (Exclusive! An Original Bond Short Story) / *What's New, Pussycat?* A Novel by Marvin H. Albert Based on an Original Screenplay by Woody Allen / Postcards—*You Only Live Twice* / *GoldenEye* / *Tomorrow Never Dies*

From Russia With Love / *Tomorrow Never Dies*—2 Shoot / *Live and Let Die* / *Tomorrow Never Dies*—2 Shoot/ 1 Shoot/ 1 S

MAGAZINES AND TOYS

A Tribute to Leonard Nimoy—Special Collectors Edition—The total guide to his life and career!

Star Special Investigation: Marilyn the FBI Files 200 Top Secret Photos & Documents

George "Gabby" Hayes—The Royal Jester of the "B" Westerns written and compiled by Mario DeMarco Mr. Whiskers' he's George "Gabby" Hayes—a talkative gent with a tattered beard and a heart of gold.

Marilyn Monroe Premiere Edition 1980 Calendar Giant Poster—revealing proof of why MM is the sex goddess

Your Unstable Journey Unstoppable—30 Days to Creating the Unstoppable You by Cynthia Kersey. Your personal action guide.

Movie Magic Collector's Edition Inside the Making of Avengers: Age of Ultron *Behind the Scenes Secrets with Cast and Crew*

Film and Television Collector's Catalog with Davy Crocket / James Bond poster / Wyatt Earp / *The Man from U.N.C.L.E.* games and oh so much more.

The Tobermory Shipwrecks by Rick and Jack Salen. The Tobermory shipwrecks—a history and description.

First draft of my first book, *Baby, Boom, Boom—Baby, It's You!* Also material not included in my book. Maybe as this book comes out, I will add it to my second edition: *Baby, Boom, Boom—Baby, It's You!*

Canadian Toy Express—Dated from Oct./Nov. 1993. My first article, which I wrote myself (four pages), on collecting James Bond for which I got a byline. Canada's first magazine of the Canadian toy collector.

Business start-up flyer—for which I took their course, also had their own TV spots. / 1998

Article: *Financial Post* / Feb. 14, 1999. "Digital Cinema Coming Soon to a Theater Near You"—Within two years, movie houses will begin installing film-free projections.

Something I sent away for that was advertised was a new projector that turns your TV into wall-size TV screen. Over two thousand sold. It works. I got a magnifying glass and converts a box to fit your thirteen-inch TV (upside down) projected on your wall. Wow!

New letter from Davy Jones' fan club—List of audio cassettes for sale (unheard demos)

Information sheet: Preoperative information about combined cataract and glauacoma surgery—graphic poster
Map—National Geography United States

Plan for a video service, which never happened—Dream Moments Collector's Showcase Catalog 001

45 RPM—Chad Allan and the Expressions (Guess Who) / "Bette Davis Eyes" / mini album: Perry Como—*We Get Letters* / *Romancing the Stone*

Visual Quick Start *QuarkXPress for Macintosh*

UV Light Source Pen for ID

Issue 39 Epilogue February 1994 / TV Zone—Supernatural Special

Western series many catalogs, still receiving, and order Western DVD movies. / Toy Collector and Price Guide—Featuring 30 Years GI Joe / Writer's Guide: Start Writing Now!

Tomart's Action Figures Digest / *Uncut Presents the Beatles*—The Beatles' Complete Story / Foothill Video Classic Home Video Mail Order Catalog / Collecting Scale Model—For the Discerning Collector Collecting Hollywood Featuring Interview Gene Autry

Toy Shop 1993 Annual Model & Toy Collector // Corgi Cars of James Bond!
Collecting Toys for Fun and Profit / Antique Toy Action / Fantasia 98 / *Star Wars Insider Bizarre* Collector's Special / *Filmfax* / *Cinefex* / *The Davy Crockett Craze: A Look at the 1950's Phenomenon and Davy Crockett Collectibles* / Scuba Diving
Your Best Bahamas Buys / Ultimate Family Getaways! No Fear—A Survival Guide to World's Ultimate Shark Dives, 10 Underwater Hazards, BC Myths

TOY BOX

Spice Girls - Photo Keys/ 3 - 24 Picture Photo Album, 2 - Picture Rulardisney - Mickey Flying Airplay - Mickey Riding Tricycle / Kide Riding Trcke / Disney - Mickey Wizard -Lady - (Lady and the Tramp)

Bear Lunch Bag - Stuffed Toys - Talking Dog (From Movie) - Corgi 100 Years of Flight -The Space Race - Bear Space Man - 2 -3 Po -Key Chain

Toy Shop Poster- Mint - 2 Cartoon Charter Mugs, Hot Wheels - Blue Suitcase Full of - *Star Wars* Key Chain Collection - 25 Piece

The X-Files - Boxed Agent Dana Scully. Agent Mulder - *Creature from the Black Lagoon* - Hockey Game (Hockey Tribal Game) Prince Phone (still works)

Mini School Locker - Sealed Box Coca-Cola 1940 Food Truck / Hot Wheels- Ford 1932 (Hot Rod) / Sealed Die-Cast Metal - 1958 Cedilla

Eldorado. Seville - Police Car / Radio Control- Porsche Racer / Bag Full of Mine - Toy Figures - California Raisins - Rug Rat

Model Plasic Kits - Westland Sea King - Rescue Helicopter - KLM - Helicopter (Sealed) - TWA - Lockheed I-1011 / Singapore Airlines A3300-B3

North Orient Dc-10 / Red Arrows Hawk / Skywave (Sealed) / F/A-18a Hornet / Sea Plan / 53 Corvette / Lamborghini Diablo (with Deuce Paint Kit)

Lost - (from TV Series) includes Island Map- with sound clips- Shannon / Austin Powers -Action Figure/ Austin Powers - Carnaby

Trading Cards Λ-3-The Andy Griffith with box - *Star Trek* Series 2 with Box - Plastic *Star Wars* Lunch Box (with beverage bottle/ juice holder/ thermos/ gape holder)

Hot Wheels - Action Pack - Mars Rover Also - 3-D Map of Mars / Tin Plate - *The Brady Bunch* / Happy Face -Touch Light (Sealed)

Action Man - Jet Extreme - (with bag full of action figures for this) / CD- Movie - They Live (this is the container the CD came in/ later removed from shelves)

Plasic Break-Away Space Shuttle - Bag Full of Disney Plush Toys - Metal Jeep - Motorcycle- Mickey Mouse (Sealed) High Bounce Ball- Sm Baby

Slicky - Micky - Jump Rope - James Bond Jr. / Jaws -Framed Photo of *The Five Pennies*
9/171 - The Joker - Makeup Kit

The Lone Ranger & Tonto- Jigsaw Puzzle (200200 Big Pieces) - Winnie the Pooh- Night Light - Tin Plate - The Blues Brothers

Limited Edition - Kellogg's Corn Flakes (2012) - Die-Cast Metal - Space Shuttle -

Cards

Coca-Cola - Cards / Classic Toys / James Bond / Campbell Soup Kids / *RoboCop 2 Teenage Mutant Ninja Turtles* / The Monkees

TV series *Lost* - Action Figure Shannon - includes a full-scale replica of Rousseau's Island Map with authentic sound clips

Car Kits

Revel Monogram Lamborghini Diablo
With Deluxe Paint Kit
Monogram '53 Corvette
Matchbox Coca-Cola Collectible
2 - 1967 Volkswagen Transporter
- 1960 Dodge-Dart Phoenix

1970 Pontiac GTO / The Whisky Trail – The Famous Grouse

3- Die-Cast Beetle Cars

Alfred Hitchcock's *Rebecca* DVD

Criterion Collection

Video Disc

Jaws 3 (not the 3D version)

Planet of the Apes—A rare find.

COOKBOOK LIBRARY

iögo the New Way to Say Yogurt. More than forty recipes to love.

Real Food for People with Diabetes by Doris Cross with Alice Williams. A diagnosis of diabetes doesn't have to mean a life sentence with tasteless food.

Preserve It Naturally: The Complete Guide to Food Dehydration, 3rd edition by Robert Scharff & Associates

Make-Ahead Cooking (Better Homes and Gardens). Make-ahead cooking buys you time!

The Original Pizza & Pasta Cookbook by Ron Kalenuik. Simple and delicious cooking series.

Rodale's Soups and Salads. Edited by Charles Gerras. Nutritional tips and entertaining visits with some remarkable cooks.

Perfect Pressure Cooking with Debra Murray. The variety of recipes, mouthwatering pictures, and Deb's tips will make pressure-cooking experiences even more enjoyable.

Pasta & Casseroles: Amazingly tasty and surprisingly simple! by Parragon Books. Included in this volume is a large range of ideas—from tasty,

familiar staples to traditional Italian favorites—for days when you are looking to offer something a little more special.

Easy Breakfast & Brunch by Susannah Blake. Simple recipes for morning treats. Start your day with one of these mouthwatering recipes. From granola and muffins to omelets and smoothies.

Betty Crocker's Red Spoon Collection: Best Recipes for Weekend Breakfasts. Featuring a breakfast express section that will have you well-fed and on your way in minutes.

Better Homes and Gardens *One-Dish Meals*. From skillet meals for every occasion.

Brain Food: Nutrition & Your Brain by Dr. Brian Morgan and Roberta Morgan. Nutrition for the brain. Operation, maintenance, and repair.

The Gourmet Versacooker Cookbook by Marian Getz. With easy-to-follow recipes, helpful tips, and mouthwatering photos to help you make the most of your VersaCooker.

America's Test Kitchen Slow Cooker. The test kitchen. Thirty slow cookers. Two hundred amazing recipes.

Peasant's Choice: More of the Best from the Urban Peasant by James Barber. Recipes from the popular television cooking series.

The New England Clam Shack Cookbook by Brooke Dojny. A wealth of "wicked good" seafood.

Artisan Bread in Five Minutes a Day: The Discovery that Revolutionized Home Baking by Jeff Hertzberg and Zoe Francois

Emeril's TV Dinners by Emeril Lagasse. Kickin' it a notch with recipes from *Emeril Live* and *Essence of Emeril* as seen on the Food Network.

Better Homes and Garden Steaks, Ribs, Chops. And all the fixins that make it great.

Grand Diplome Cooking Course by Anne Willan. Never before has anyone published a series of books that guide you from the basics of good cooking to the completed dishes that make that special occasion really special.

George Foreman's Knock-Out-the-Fat Barbecue and Grilling Cookbook by George Foreman and Cherie Calbom. Finally, the heavyweight champ reveals his secret of high energy, big flour, and low-fat cooking!

Consumed: Why Americans Hate, Love, and Fear Food by Michelle Stacey This is a straightforward, common-sense approach to how to eat and drink—how to enjoy the good life.

Roadfood by Jane and Michael Stern. The coast-to-coast guide to seven hundred of the best barbecue joints, lobster shacks, ice cream parlors, highway diners, and much more.

In Defense of Food: An Eater's Manifesto by Michael Pollan. "Eat food. Not too much. Mostly plants." "Outstanding . . . a wide-ranging invitation to think through the moral ramifications of our eating habits."

50th Anniversary

—The Beatles
—*Star Trek*
—The Monkees
—*Doctor Who*

MOVIES

—*The Graduate*
—*Bonnie and Clyde*
—*A Hard Day's Night*
—*The Sound of Music*
—*Charlie Brown*
—*Mary Poppins*
—*My Fair Lady*
—*Ben-Hur*
—*The Muppet Christmas Carol*
—*To Kill a Mockingbird*
—*12 Angry Men*
—*Lady and the Tramp*
—*The Sword and the Stone*
—*The Nutty Professor*
—*Breakfast at Tiffany's*
—*West Side Story*
—*The Searchers*
—*The King and I*
—*Forbbiden Planet*
—*North by Northwest*
—*Sleeping Beauty*
—*Charade*

All these movies and everything are very collectible.
And the list grows each year.
And maybe yours will too.

Which means, my fine friend, the reason why we all collect is because of the hope that what we collect will be worth a fortune! Words like *limited edition* and *only a limited amount is made* gives you a greater chance to cash in someday. There is the cost: the lesser amount made, the greater the chance it will be worth even more. There are all kinds of price guides on whatever you collect and all kinds of TV shows on people collecting on any one subject then telling their value. Your chance of getting it in today's market is very slim. If anything, you get a lesser amount than what you paid for it. The real goal in collecting is the search. I have sold many of my collections and picked up a lot of great buys, but the real fun is seeing someone's face light up when they see what they have been looking for for a long time.

What fun there is to be had and how easy we can you get into hoarding and how the market is set up for you wanting to spend more on the latest movie collectible edition, such as the fiftieth anniversary.

The reissue of an individual album from the Beatles' catalog with an expanded and newly remixed edition of the Fab Four's 1967 pop masterpiece *Sgt. Pepper's Lonely Hearts Club Band* was ranked by critics and fans as one of the most influential rock albums of all time. *Sgt. Pepper* is being reissued in multiple formats and editions, including new stereo and surround-sound audio mixes along with nearly three dozen previously unreleased recordings from the same sessions. Upcoming is the fiftieth anniversary of the Beatles' White Album, another must-have for Beatles fans.

COLLECTING TODAY

At long last, my beloved toys show are coming back in full swing along with video games, comics, and records shows. Ya!

This all happened in the year 2017 and is happening every four months. All this after a long wait and because of SARS and increase in rents, causing a sudden closure of all kinds of collectible shows for many long years. I never gave up hope that everything would return. Return, yes but not exactly the same in much smaller places. Before, I would be in a warehouse. Likely, I film many of these shows in video. I had so many happy memories, grabbing all kinds of deals. My last show—it was not so good with the price cost far too high. This year, I got more things online. I felt this would be my last show. Maybe because I had so much, but like so many things in my life, they are so addictive!

WHAT NEW THINGS I'M COLLECTING THIS YEAR

I'm starting to get my past super 8mm films digitized and make it so I can send my film online. Now everyone can see what I've done. I ordered some toys online from a company called Big Bad Toy Store and from Corgi. They are all movie- and James Bond–related. There are even more books on the Beatles and the Monkees that all look very interesting. With all my into researching further in my area of interest. It is all about what is the long-term attraction in what we spend on in pop culture.

"This is the end my friend, this is the end my friend," as sung by the Doors in the classic film *Apocalypse Now*.

These are such troubled times. Where has everything gone? The places where we shopped, worked, and experienced are gone, gone, gone! 'Tis progress they say. I have some many magic moments saved. I am so lucky we can all relive the best of times. I am more than just an aging baby boomer! I collect what makes me happy. For what I say about how we all have been, how we all have been duped, conned, and persuaded in what we spend in life and in what we collect, that's okay. It's all about what makes you happy. As to why we collect, it all about finding new ways to get more money on the same product or movie and TV show.

This is my sequel to my first book, *Baby, Boom, Boom—Baby, It's You!* The book you you hold is *My Collection, Maybe Yours*. Like the first book, the theme is on consumer spending as told my your friendly neighborhood self-appointed baby boomer consumer advocate.

As you see a small part of what I collect, I hope you find something you would like. Maybe you can run out and buy as you see what is available.

WHAT DO YOU COLLECT?

Why do people collect? That depends on when you were born. I am a baby boomer. That means I was born anywhere between 1946–1964 (eighteen years). We grew up in front of the TV. We all had so many memories growing up with music, movies, and popular culture. As each decade unfolded, it was more even so with so many icons and heroes through the many years. What did you want to be when you grew up? What inspired you? With filmmakers like Steven Spielberg. He was so thrilled with all the spy films that came out in the 1950s and 1960s. If you've seen *Star Trek* or *Lost in Space*, you wanted to be part of the space race.

So to us kids, we wanted everything connected with any show or music. And so my first collection began. For many, it was different. It would be hockey cards, movies, and TV shows or music. For me, it was a TV show called *The Aquanauts*, all about a team of scuba divers located in California. I very much wanted to be like them. Everyone has their own stories of what inspired them enough to have a career in that field. For many, they just wanted to just collect, and we did.

By 1970, the term *limited edition* appeared. That meant one day it would be—never mind what you had, you just had to have it all!

Now here and now with what is happening with the Marvel/DC universe, you (and technology) just have anything connected! Never

mind what you have, you just have it all. I am all for that, but you've got to be careful it doesn't get out of hand! You may get into hoarding.

What does *limited edition* really mean?

"The terms special edition, limited edition, and variants such as deluxe edition, or collector's edition, are used as a marketing incentive for various kinds of products, originally published products related to the arts, such as books, prints, video games or recorded music and films, but now including clothing, cars, fine wine, and whisky."

That is the promise, but there is now guarantee that you are going to make more money than it is worth.

"Let the buyer beware" . . . in the law of commercial transactions, principle that the buyer purchases at his own risk in the absence of an express warranty in the contract."

Top-Grossing Films in the 1970s

Star Wars (1970) / *Jaws* (1975) / *Superman* (1978) / *The Godfather 2* (1974)
One Flew over the Cuckoo's Nest (1975) / *Taxi Driver* (1976) and *The French Connection* (1971)

Popular TV shows

*All in the Family, M*A*S*H, Happy Days, Mork & Mindy, The Six Million Dollar Man, The Brady Bunch,* and *Wonder Woman*

All would be about their own licensed products, games, and toys.

Popular Music

The Beatles, Fleetwood Mac, ABBA, ELO (Electric Light Orchestra), Deep Purple, Yes, Supertramp, The Moody Blues, Alice Cooper, Kiss, and Jethro Tull.

Plus many more that would set the tone and excitement brought in current times in this decade.

These would all produce top hits, which would be remastered, made into box sets, and come back into stereo and albums on 180g vinyl.

As a collector of music, no matter if you already have the record, you just must have the mono. And on heavyweight 180g vinyl. And don't forget all the concerts you must attend.

Fads and Fashion

Tie-dye, T-shirts, bell-bottoms, disco suits with gold chains. On Earth Day, you needed to plant a tree.

ecorder

1970 Big Inventions

Datamax/VHS

There was a war over which would be the better recorder machine. The winner was VHS (video cassette recorder).

By 1972, the word processor was invented. In 1975, the laser disc came out. The first ink printer was invented. In 1979, the cell phone came out. Do you remember how big it was?

Top-Grossing Movies of the 1980s

Star Wars: The Empire Strikes Back (1980), *The Blues Brothers* (1980), *Romancing the Stone* (1984), *Ghostbusters* (1984), *Beetlejuice* (1988), *Big* (1988), *Nine to Five* (1980), *Flash Dance* (1983), *Arthur* (1981), *The Terminator* (1984), *Footloose* (1984), *Cocoon,* (1985), *Raiders of the Lost Ark* (1981)

Famous People Who Died in the 1980s

Alfred Hitchcock, Peter Sellers, Steve McQueen, and John Lennon

Year 2000 Y2K Threat

We were hit by a recession, even worse, Y2K.
As a worker and collector, I was hit; but it did not stop me from great deals. We were all hit and were forced to be careful about how we spent our money.

New Technology

GPS devices, Blackberry, digital camera, Wii, USB flash drive, iPhone, e-reader. Our lives were forever changed.

Top Movies of the 2000

Lord of the Rings 1, 2, and up, *The Incredibles, Wall-E, Crouching Tiger, Hidden Dragon, The Dark Knight*

Even More Technology

Wireless speakers, YouTube, headphones, Bluetooth, camera / video/ cell phone, digital satellite radio, and artificial liver.

The End of Movie and TV Series Once Again

In each decade, technology changes. So do formats—DVD/ BLU-RAY, HD, 4K—and there will be even more changes to come.
What is the collector to do? So many changes, no more movie rental stores, and watching TV is not the same.

This year the of TV series and movies like *Star Wars*. Many icons die. Many big-name stores are no longer.

There are still many ways many lost TV shows and movies can be available. Many retro TV shows are available, such as *I Love Lucy, The Mary Tyler Moore Show, Rhoda, Taxi, Mission: Impossible, Lost in Space, Mork & Mindy, Cheers, Happy Days, M*A*S*H*, as well all of the *Star Trek* origin series and spin-off shows, which all gets you into you getting your own box set of these gem shows, all of which you can record on your DVR. Luckily for me, I have recorded many of these shows, plus music and new events and *Icon* bio specials on VHS and DVD recorder.

Good news for people who collect. Here are more things I collected this year: Hot Wheels, and the Beatles LP (Remastered 180g vinyl).

- 50th Anniversary White Album 180g Lowl Ive – Hollywood, Jethro Tull – Aqualung 180g, Corgi – Cars/ *GoldenEye, The Living Daylights* - Book – *Power Rangers: The Ultimate Visual History*, *Ghostbusters* Ectomobile – Owers Workshop Manual, *Doctor Who* Cyberman Figure Collection – with four figures from different decades with book.

FINAL CHAPTER

Newsletter/Catalogs

- Best British shows – www.britbox.com \ music - www.jagmart.com
- Video conversion - www.digitaltreasurygroup.com / Toys - www.bigbadtoystore.com / music/movies – www.universe.com
- Best Die-cast - www.corgi.com / Best store – www.bestbuy.ca
- Books – www.powell.com / horror movies – www.shutter.com

All kinds of treasures to be found such as in the DVD limited edition collector's gift set, such as in *Spider-Man*.

In it contains

Gift Set includes:

- *Spider-Man* widescreen 2-disc DVD
- *Stan Lee's Mutants, Monsters & Marvels* DVD
- Collectible reprint of *Amazing Fantasy* #15, which introduced the Spider-Man character
- Collectible "featuring a film cell from the movie personally selected by the director with this comments
- Limited edition off-set lithograph reproduction by John Romina Sr. and John Romina Jr. (Spider-Man artists)
- Spider-Man DVD includes:

- Commentary by director Sam Raimi, Kirsten Dunst, producer Laura Ziskin, and co-producer Grant Curtis
- SFX commentary by special effects designer John Dykstra and visual effects crew
- "Weaving the Web": subtitled pop-on production notes and historical facts

What is so amazing is that I picked it up at a collector show for only $10.00. You must act fast! Sometimes I pick up items for $1.00, and I can sell them for $10,00.

CONCEPT OF COLLECTING

Wikipedia states

"For people who collect, the value of their collections are not monetary but emotional. The collections allow people to relive their childhood, connect themselves to a period or to a time they feel strongly about. Their collections help them ease insecurity and anxiety about losing a part of themselves and to keep the past to continue to exist in the present.[1] Some collect for the thrill of the hunt. For these collectors, collecting is a quest, a lifelong pursuit which can never be completed. [2] Collecting may provide psychological security by filling a part of the self one feels is missing or is void of meaning.[3] When one collects, one experiments with arranging, organizing, and as part of the world which may serve to provide a safety zone, a place of refuge where fears are calmed and insecurity is managed.[4] Motives are not mutually exclusive, rather, different motives combine for each collector for a multitude of reasons."

My Views, the Way I See It

Right on, brother, but I think it is much more than that. As I said in my first book, *Baby, Boom, Boom—Baby It's You!* This would show through marketing strategies they get us to buy their products. We have been duped, conned, and persuaded into wanting to buy at whatever the cost.

This is the theme of which I write about, but I am the first one that gets addicted to this with their sales pitch. "Get it now with our easy payment plan." I quickly set out to order it, always with the words, "You must act now!"

The thing is, I must act quickly. Great, but just look around. See how much I have. Is there no end? I think with all the books I own, I should have enough to add to my income with all the knowledge in front of me.

I hope, my dear fellow collector. I do hope you have a plan or maybe a career or an enterprise.

Say, friend, are you looking next collectible item? With all the exciting news coming out such as scientists releasing the first images of a black hole or the death of pop icons like David Bowie or Aretha Franklin, there are all kinds of TV specials you can record on your DVR and DVD recorder. Along with ultimate collector's edition (magazines) of many of the greatest icons such as the Beatles, the Beach Boys, *I Love Lucy*, and John Lennon. Along with the latest movies such as the latest Marvel adventure. All for a very low price—but wait, fans! There is so much more.

You get it!

The end is near.

With the end of TV series like *Game of Thrones*, *The Big Bang Theory*, the last *Star Wars: The Rise of Skywalker*, and the last time actor Daniel Craig will play James Bond, for sure, there will be more products to buy and spin-offs to watch.

So much more to add more to your collection

So much is happening in the world of entertainment, sports, comics, and antiques. So much to collect—top movies, sport teams, and sports

figures. There's a lot of research to do, money to be made, and so much fun to be had in the chase.

And may be yours.

As you can see by my list of all that I've collected, I hope to give you some idea what you can collect. I know that what I've got may seem far too much, but I know more people collect much, much more.

As I tell people for people who don't collect, I simply say, "It's not what it is, but what it represents!"

WHAT DO YOU COLLECT?

That depends on what demographic you belong to. If you grew up in the 1960s and 1970s, you are either a Trekkie or a *Star Wars* fan. Or maybe you're more into Marvel or DC Universe. Either way, you know you were hooked into reliving the adventure. For me, I was there in the beginning as a baby boomer with all that was on TV, music, and movies. It was all a good place to bring you back to all the thrill of your heroes and how one day you, too, can ride off into the sunset. For me, I did one better. I got to act out a role just like my hero and do the very things they did. With what you collect, you buy movies, music, toys, and anything connected with these treasured moments. I am very sure what I collect is what people stored in their closets. So sad, I thought, they should be sure what they collect to their friends and to the world.

For what your collect and are attracted to is part of a million—no, trillion—dollar industry that grabs your attraction.

Here it begins—my search on how we as baby boomers and generations beyond get caught up once in a never-ending spend cycle that must be met, as each decade unfolds, as each generation get sucked into being duped and persuaded. This would be the beginning of your spending habits. You are very much targeted. Many do not care! I, too, get caught up in this friendship. Difference is, I care and dare to ask why. Why

do we need to collect so much? So says I, your friendly neighborhood self-appointed baby boomer consumer advocate.

Baby, Boom, Boom—Baby, It's You! Volume 3

Will return!

The End

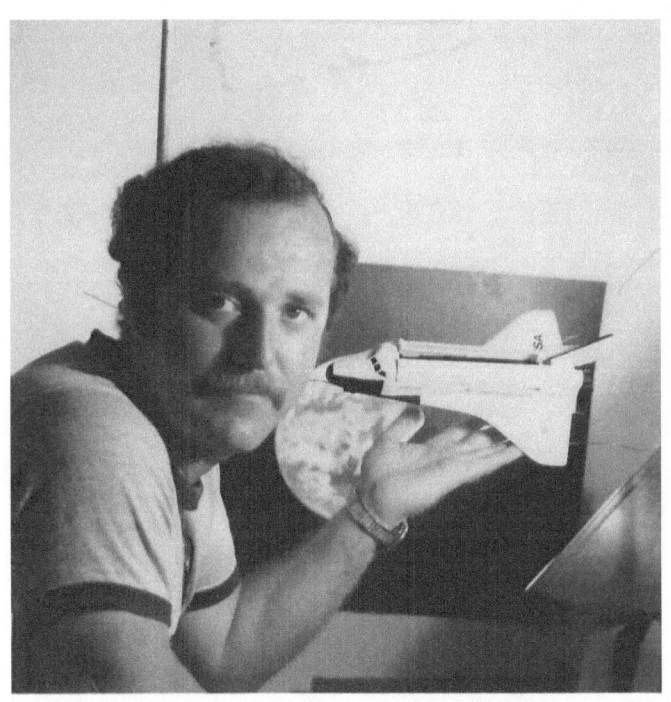

Terry Wayne Brownlee

www.ingramcontent.com/pod-product-compliance
Lightning Source LLC
Chambersburg PA
CBHW021511210526
45463CB00002B/984